I am the lover and the loved,
home and wanderer, she who splits
firewood and she who knocks, a stranger
in the storm, two women, eye to eye
measuring each other's spirit, each other's
limitless desire,

 a whole new poetry beginning here.

Adrienne Rich
"Transcendental Etude"

JEB (Joan E. Biren)
Eye to Eye: Portraits of Lesbians

Originally published in 1979 by Glad Hag Books
This edition published by Anthology Editions, 2021
With thanks to the Sophia Smith Collection of Women's History, Special Collections Department, Smith College

Publication © 2021 Anthology Editions
Images © 2021 JEB (Joan E. Biren)

Edited by JEB and Grace Srinivasiah
Designed by JEB and Bryan Cipolla
Images edited by JEB and Kristine Eudey
Originally typeset in Korinna and Megaron by *The Washington Blade*

First Edition
Third Printing

Printed in Shenzhen, China on FSC-certified paper
Library of Congress Catalog Card Number: 2020943137
ISBN: 978-1-944860-37-0

anthologyeditions.com
87 Guernsey Street
Brooklyn, NY 11222

PHOTOGRAPHS BY JEB

EYE TO EYE:
PORTRAITS OF LESBIANS

ESSAYS CONTRIBUTED BY:
JOAN NESTLE • LOLA FLASH • TEE A. CORINNE
JUDITH SCHWARZ • LORI LINDSEY

Anthology Editions • New York • 2021

THIS BOOK IS DEDICATED WITH LOVE AND RESPECT
TO ALL THE LESBIANS I HAVE PHOTOGRAPHED.
THANK YOU FOR YOUR COURAGE AND YOUR TRUST.

A photographer's work is to see things; we are professional see-ers. Usually we see what we look for and so our seeing actually becomes selecting. We choose the people, the settings and the situations that we transfer to film from among all the possible images in the world around us. I've chosen the images that best express to me the strength, beauty and diversity of Lesbian womyn. I believe our will to survive and our love of life are powerful. I have tried to convey some of that energy through these photographs.

Every womon here is proud of herself and her Lesbianism. In this way, some of the people in the book helped to select themselves and their situations for publication. Still, the time (money) for this project has been limited and much that I would have liked to include is missing. Perhaps I should have subtitled the book *Only Portraits and of Just a Very Few Lesbians*.

I want to thank all the Lesbians who shared their opinions of my photographs with me, especially the womyn of the Washington, DC community. *Eye to Eye: Portraits of Lesbians* would not be a reality without the financial support of many generous womyn, and I want to thank them for sharing their money.

I am grateful to many womyn and their publishers for permission to reprint here words that have first appeared elsewhere. Other quotations in this book are from the womyn in the photographs. Most of these I edited from tape-recorded interviews; a few womyn composed their own quotations. A bibliography of sources and resources connected to the quotations starts on page 86.

The forms of the words womon/woman, womyn/wimmin/women, Lesbian/lesbian, and herstory/history vary in this book. This is not accidental. It is part of re-creating our own language.

I want to acknowledge the womyn who encouraged me when I was discouraged, whose web of love and support bounced me back many times. I have been blessed with many dear friends who helped me to do this work, but I am naming only a few. I hope all of you will know my deep appreciation.

Thank you: for getting me started, Sue Brennan; for sustaining me along the road, Deb Edel and Joan Nestle; for constant inspiration, all the PTW's; for a wonderful introduction and more, Judith Schwarz; for helping me through the final stages, Linda McGonigal; and for telling the truth, Mary Lee Farmer; for editing and proofing, Marge DuMond; for guiding me through the design, layout and printing processes, Sarna Marcus; for their financial support throughout this project and their enduring friendship, Dee Mosbacher and Nanette Gartrell; and for loving and believing in me, Toni White.

Throughout the forty-plus years since the first publication of *Eye to Eye*, I have been profoundly moved by people sharing with me the significance of the book in their lives. I am grateful to Anthology Editions, especially Jesse Pollock, Grace Srinivasiah, and Bryan Cipolla, who made it possible for new generations to see this work. I was fortunate to be able to work with Kristine Eudey to bring the images back to life. Huge radical love and gratitude to my chosen family for holding me always.

JEB (Joan E. Biren) Silver Spring, MD

Foreword

JEB's photographs form a mosaic of Lesbian strength, of our strivings to remake our outer and inner worlds. Lesbian strength is not a simple subject; it is a mix of gentleness and power, play and combat, self-cherishing and communal commitment. It is a strength based not on the conquering of a weaker adversary, but on the refusal to be less than who we are. It is a strength nourished by our rejection of one world and the joyous, glorious and difficult dedication to the creation of another.

In growing, struggling, working and playing, there is a Lesbian way— a taking on of the challenge to keep woman-wholeness in a patriarchal world. These photographs celebrate both our physical transformations and our emotional wisdom. They give us a visual record of our passages. JEB sees to the heart of us. In her portraits, we can recognize our power, our endurance and our energy.

Years ago when we were a more hidden people, we used eye searching to find each other; we dared to look longer than we should and, through this brave journeying of our eyes, we found one another. It was a secret language that gave permission for a secret act. But always glowing beneath the secrecy was the force of our spirit.

Now we are a visually emerging people and we must be so, for we cannot survive visual silence just as we cannot survive the silencing of our voices. Our spirit is secret no longer. Gone are the half-glance and the lowered lid; here we see each other eye to eye.

Joan Nestle
Lesbian Herstory Archives
1979

Introduction

JEB is responsible for single-handedly creating a groundbreaking collection of photographs that chronicle an era in our shared lesbian, and therefore queer, history. Truth be told, when I first met JEB, I wanted to acknowledge my appreciation for her selfless contribution, through both the images in this book and her career as a whole.

Spurred on by the second wave of feminism, the Civil Rights movement, the Vietnam War, and her involvement with the Furies (a radical socialist lesbian feminist group), JEB realized that, counter to her original intention of working toward her PhD in political science at the University of Oxford, she was headed along a very different trajectory. Because of her privileged education—she had been an undergraduate at Mount Holyoke College—JEB was rebuked by her activist peers and told she spoke with a "prick in the head," meaning she had been taught to think in patriarchal modus. As a consequence, JEB changed course and began a revolutionary personal project.

Through photography, she found a way to expand her political views and tackle her desire to make an invisible community visible. JEB employs inclusion—in her words, "the humanity that we share"—as the political foundation of her work.

I feel a kindred spirit in JEB. Unlike many lauded queer photographers, she and I have strived intentionally for decades to create bodies of work that challenge an assumed norm—photographing outside our communities, photographing not just what we know. My own practice is entrenched in advocating for social justice around issues of sexual, racial, and cultural difference. For me, this fuels a lifelong commitment to not only make visible but also preserve the legacy of LGBTQIA+ people and communities of color. Like JEB's, my art and activism are deeply intertwined, and we conceive our works out of not hierarchy but the idea of unity and multiplicity—which wreaks havoc on the status quo.

In this glorious book lies JEB's road trip across America. It holds exquisite images of lesbians who are poor and rich, Black and white, old and young, with and without disabilities. It's an intersectional representation that includes not only her friends but also a deliberate assortment of women from many walks of life.

JEB is intentional and rigorous in her inclusion. She ensures that each of us can not only find ourselves in her work but also enjoy a comprehensive pride that is often otherwise denied. These images have as much impact and importance today as they did when this book was first published in 1979.

As one can imagine, in 1979 publishers were not ready to release a book of lesbian photography, so JEB had no choice but to take an old-school crowdsourcing approach to self-publishing her work. Additionally, presses did not want to print the word "Lesbian" on a book cover, imagining that they could be liable for labeling the women in the book as *Lesbians*—even though JEB obtained model releases from the women, further paperwork indemnifying the press had to be drawn up.

One of my favorite images is the portrait of the twin sisters Barbara and Beverly Smith, who went on to become staunch Black lesbian feminists. Centered between them is a typewriter, hinting at the pair's academic prowess, and both have a relaxed joy about them.

There is no doubt in my mind that each of you will find in this book a gem that you can latch on to and in so doing feel the presence of a virtuoso documentarian. More than that, you will recognize a spirit who values our community's combined strengths and our bewitching deviations. From her loving eye to yours, JEB's work was ahead of its time, is of its time, and will live on until the end of time.

Lola Flash

When There Were No Images:
The Remarkable Achievements of JEB

More than any other lesbian photographer working in the United States in the final decades of the twentieth century, JEB has changed how lesbians are pictured.

In the early 1970s, JEB longed for pictures that reflected her own reality, and there weren't any to be found. It is hard, today, to imagine the total absence of publicly available images of lesbians, or to feel the negation that absence both represented and fueled. JEB's photographs brought to an international audience images of lesbians, face forward and identifiably lit, taking their place in the visual lexicon of an era. Her images were so right, so much like a way of life, so comfortable, that after seeing them one can't imagine a world without them. Those images graphically established significant lesbian and feminist themes: inclusivity of race, ethnicity, and age; political activism; bonding between and among women; empowerment of those with physical and psychological disabilities; lesbian mothering; and feminist spirituality.

Eye to Eye begins with a loving confrontation. Two women face each other on the book's cover. They are not young women, yet the contact is erotic. One has a slight beard. They are like many lesbians we all know, yet unlike any that had ever been pictured before. In their joy, their age, their unconcern for the niceties of American cultural norms, they define a new territory into which lesbian and bisexual women can move. *Eye to Eye* represents a decade's worth of learning new ways in which to relate to one another. It shows personal lives made public in small acts of valor.

JEB has continually been in the right place at the right time with the right awareness. She brings to her endeavors a naturally fine aesthetic sense, quick reflexes, and a willingness to take risks. The times demanded a documenter and she said yes, and that yes is echoed in capital letters in each of her many photographs.

At the twentieth century's end, when a celebration of alienation has come to dominate institutionally supported lesbian imagery, JEB's work radiates qualities that inspire: truth, honesty, caring, community, and women's love for each other. These photographs have staying power—they will endure.

Tee A. Corinne
1997

Lesbian Photography

A Long Tradition

Since its invention in 1839, photography has always attracted lesbians and other strong, independent and imaginative women. They have used it to communicate their creative vision, support themselves financially and record their world and their lives—though their lives have been (and continue to be) consistently ignored, devalued and distorted. These women felt compelled to learn the innumerable technical details that convert a photographic plate or film into a lasting image for future generations. These women were also (consciously or not) actively refusing to acquiesce in the tradition of the anonymous woman.

Lesbians, especially, have been drawn to photography in such numbers that only the writers outnumber the photographers in our creative history. Many lesbian photographers are unknown to us. Their lives, their work and the images they created have been lost to us through decay, neglect or intentional destruction. Yet many have left their women-loving imprint upon photographic history, and these we celebrate here. There is strong biographical evidence in manuscripts and diaries for some of our lesbian foresisters; others we claim simply because they never displayed any overt heterosexual behavior. The true evidence is in their photographs.

From its founding in 1853, the Royal Photographic Society in London admitted both men and "ladies" to membership.[1] One of the ladies was the Viscountess Clementina Hawarden (1822–65). Tee Corinne, a modern lesbian photographer, wrote: "In Hawarden's photographs of two women together, the women almost always touch each other, often they embrace. Some couples seem about to kiss, others look as if a shared intimacy had just been interrupted."[2] Lady Hawarden's prints won the highest praise from the jury of the Dublin Exhibition in 1865. She did not fare nearly as well in the catalog commentary for the 1975 "Women in Photography: An Historical Survey" show at the San Francisco Museum of Art. There her work is described as the "product of a singularly barren imagination. . . mawkish and repetitive. . . ."[3] Hmmm. Any lesbian who has seen Hawarden's work, which appeared in *Sinister Wisdom* 5, would find herself moved to either laughter or anger at that judgment.

In the US, women soon discovered the camera's potential as a money-maker. Only five years after photography became a practical means of obtaining a human likeness, Sarah Holcomb became an itinerant photographer.[4] In 1846, carting her chemicals, camera and other tools of her trade, she moved from Boston to Manchester, New Hampshire, and on to Claremont, New Hampshire. She was one of the first of thousands of women (almost all of whom were single, widowed or divorced) who supported themselves through a combination of chemical and technical expertise, business skills, courage and the physical strength needed to carry the cumbersome equipment. As Annie Gottlieb wrote in *Women See Woman*:

> An art so new was not surrounded by entrenched taboos or possessed by the mystique of brotherhood; was not, for that matter, taken seriously as an art, any more than women were taken seriously as artists. This gave women a paradoxical advantage in gaining a foothold.[5]

Still, a woman who chose photography as a means of creative expression or as a way of making a living "had to have the courage and drive (and, if she was lucky, the social position and emotional support) to defy persistent norms of female

behavior."[6] For a lesbian who had already defied the prevailing heterosexual model for relationships, defying another norm was small potatoes, especially when she stood to gain financial independence through photography.

By 1900, 3,580 professional women photographers were counted in the official US census. Well over two thirds were single women and nine were Black women.[7] This seemingly high overall figure includes only the photographers who owned their own studios, not the multitude of "amateurs," who may have earned money in their own homes. Amateur was defined in the census as a person who did not have a studio; it did not mean she did not sell her work. The census figure also gives no hint of the numbers of women earning their living as laboratory technicians, as photographer's assistants or in the new field of photojournalism.

Such a narrow definition surely would have left out a photographer like Emma Jane Gay (1830–1919). During Gay's long working career, which began when she and a close friend founded a girls' school in 1856, she wore many hats, including tutor to President Andrew Johnson's grandchildren, suffragette, Washington political hostess, architect and, for seventeen years, a clerk at the Dead Letter Office.[8]

Gay became a professional photographer only by merest chance. In 1888, she took a good long look at her friend, the noted ethnologist and Indigenous peoples rights advocate Alice Fletcher, who had just returned from an arduous trip out West. Distressed at Fletcher's haggard and exhausted appearance, Emma Jane Gay offered her services to "look after" and cook for her friend on the next trip out in the field. But the Interior Department's budget for Fletcher's project only carried a listing for photographer, one of the few skills Gay had not yet learned. She spent the next few months learning how to handle the chemicals and develop the photographs. Finally, in the summer of 1889, she joined Fletcher in Nebraska. For the next three years Gay was the official government photographer for Fletcher's land-allotment work among the Nez Percé tribe in Idaho; unofficially, she did all the cooking and daily camp chores.

When Emma Jane Gay learned photography, she was fifty-nine years old and she hardly expected to make a new career out of it. Photography was merely a means to be with Alice Fletcher. Gay's lucid and witty letters home to her family, along with many of her photos, were eventually collected into two beautifully handbound volumes.[9] In 1893, Fletcher and Gay returned to Washington and settled down on Capitol Hill (not far from where JEB lives today).

Washington, DC, has proved to be an unexpectedly fertile ground for developing lesbian photographers. At the same time that Emma Jane Gay was photographing the lives of the Nez Percé, Frances Benjamin Johnston (1864–1952) was beginning her extremely long career as one of the leading documentary, portrait and architectural photographers in the US (as well as one of the first photojournalists). Gay's and Johnston's circles of Washington acquaintances overlapped, and the two women may even have met. But Johnston's papers—some 17,000 items of correspondence—leave us grasping for clues to her private life and friends.

> She was a fiercely independent person who often scoffed at social conventions; yet her private life remains hidden behind a veil of Victorian manners . . . Her letters speak lightly of the weather, of travel, and other polite topics that frustrate the biographer . . . Johnston never married, but devoted her life to photography. Any love affairs she may have had are not revealed in her correspondence. How she felt on social issues or other topics is seldom discussed except as it relates to her work. The single best source to study her life is her photographs . . . Her camera was her diary.[10]

What her photographs reveal is a woman passionately interested in the lives and working conditions of Pennsylvania coal miners, Massachusetts women shoe-factory workers, Lake Superior iron-ore miners, and the sailors on Admiral Dewey's battleships (including a charming photo of sailors dancing cheek to cheek on the deck). Her photographs of the students at Hampton Institute and Tuskegee Institute stand as first-rate examples of her style and convey the rapport between photographer and subjects established during the long days of posing.

Although Johnston photographed almost all the leading people of her time, including George Washington Carver, Mark Twain, Susan B. Anthony, Theodore Roosevelt and Helen Hay Whitney (who wrote lesbian poetry), Johnston's most famous portrait may well be one she took of herself in 1896. In a pose shockingly unlike any other of her era, Johnston holds a cigarette in one hand, and a beer stein in the other. One elbow leans casually on her right leg, which is crossed at the ankle on her left knee, exposing her white eyelet petticoat and black stockings. A boyish cap is perched above her solemn face. She does not look like someone you would easily trifle with. In her day, Johnston was considered eccentric and Bohemian in private, given to fancy costume parties in her studio, yet a serious professional of great talent in her public life. After a long and fruitful career, Frances Benjamin Johnston died in New Orleans after seeing her work honored by the Library of Congress and many other institutions.

Alice Austen (1866–1952) was Johnston's contemporary in age, social position and quantity of her work; some say she surpasses Johnston in the quality and warmth of her photographs. Born a favored only child to a wealthy Staten Island clan, Austen learned how to use her sea-captain uncle's camera at the age of ten. She photographed nearly everything she saw, yet she always thought of photography as merely a hobby.

Austen seldom sold any of her work, even after her family fortune was lost in the 1929 stock market crash. She and Gertrude Tate, her lifelong friend and lover, were reduced to running a dancing school and tea room in a vain effort to save Austen's home. When the home was lost, 7,000 of her marvelous pictures and glass-plate negatives were preserved only by a fortunate accident. Then they sat in a storeroom of the Staten Island Historical Society for years, neglected and forgotten like Austen, who very nearly died in a poorhouse. It was not until she was eighty-five years old, when her work was discovered by a researcher for a pictorial history book, *The Revolt of American Women*, that Austen's "hobby" suddenly brought her fame and enough money to move to a private nursing home.[11]

Austen's lively, funny and charming portraits of herself and her friends include many playful lesbian images. She photographed herself and a girlfriend in her bedroom dressed only in their underclothes, black stockings and masks, smoking cigarettes; herself with two women friends dressed in men's suits, vests, bowler hats and painted-on moustaches; and a formally posed Victorian family gathering that looks rather typically dull to the eye, until you notice two young women in the foreground, gazing longingly into each other's eyes and holding hands.

Berenice Abbott, born in 1898, is the best-known photographer of lesbians. Her enviable reputation was well established in Paris in the 1920s, when she supported herself with a portrait studio. Her photographs of Janet Flanner, Margaret Anderson, Princess Eugènie Murat, Jane Heap, Edna St. Vincent Millay and other famous lesbians, homosexuals, writers and intellectuals of the era stand as a historic record of the upper-class Parisian lesbian community. The portraits are strong images, almost every person gazing right into the viewer's eyes. As one writer has said of Abbott's work, "You won't find much flattery in Abbott's portraits . . . Her work is refreshingly straightforward—strong, clear pictures with art but without pretense."[12] In 1929, Abbott returned to the US and

gave up photographing people to begin photographing New York City during the Depression. Later she expanded her work even more, experimenting with new techniques and her own inventions while photographing scientific subjects— penicillin mold and soap bubbles never looked so unearthly and beautiful.

Now working and living in Maine, Abbott has written about her views of photography. "I agree that all good photographs are good documents, but . . . a good photographer does not merely document. [S]he probes the subject, [s]he explores and discovers the world [s]he lives in. . . . Living photography does not blink at the fantastic phenomena of real life, be it beautiful or disgraceful. Photography cannot ignore the great challenge to reveal and celebrate reality."[13]

Carrying On

Lesbian reality is not visible in the mass media. We cannot find positive images of ourselves in most magazines, on television or on the movie screen. Lesbians have battled false and heterosexual images with personal snapshots, giving photograph albums a place of honor in our homes. In some parts of the country during the 1950s and '60s, lesbians happily gathered together for "home-movie night." Astonishing numbers of us have worked in photofinishing plants and camera stores for big discounts and low wages.

The emergence of lesbian-feminism as a political movement in the early 1970s intensified the desire for visibility among some lesbians. One woman who began to photograph lesbians at this time was JEB (Joan E. Biren). "I had never seen a picture of two women kissing and I wanted to **see** it. I borrowed a camera, but I didn't even know anybody else I could ask to pose for it. So I held the camera out at arm's length and kissed my lover, Sharon, and took the picture. That's my first lesbian photograph."[14]

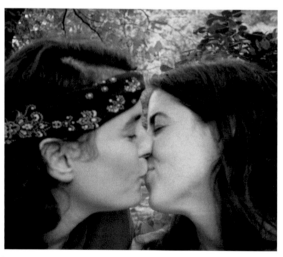

JEB taught herself photography through a correspondence course and through jobs in a camera store, a small-town weekly newspaper and the audio-visual division of a large trade association. Providing photographs at cost for lesbian and women's movement groups also helped to increase JEB's skills and, in 1975, led to assignments for commercial clients. Since then, as a freelance photographer, she has supported herself with accounts that include TV stations, theater groups and advertising agencies.

JEB's photographs have appeared in many lesbian, feminist and gay publications, including *The Furies*, *off our backs*, the special issue of *motive*, *Quest* and *Our Right to Love*.[15] She published *A Calendar for Women* in 1974 and 1976 and has done the photography for record album covers including Willie Tyson's *Full Count* and *Debutante*, Casse Culver's *Three Gypsies* and Meg Christian's *I Know You Know*.

In the 1970s lesbian photography began coming into its own at last, under its own name. The list of contemporary lesbian photographers includes many outstanding women. A working community of lesbian photographers is finally beginning to evolve and women like JEB are getting their work before a larger public.

"... To reveal and celebrate reality," as Berenice Abbott said. What better reason to rejoice in the fact that so many lesbians have been drawn to communicate through photography? Those of us who are not photographers have our own role to play in the future of lesbian photography. We need to search out the Alice Austens in our own communities and assure the lesbian photographers working today that their work will find a receptive and critical audience.

Judith Schwarz
1979

* * *

Judith Schwarz, who worked for twelve years in photofinishing plants, has been researching American lesbian history since 1974. Her published work includes the autobiographical article "On Being Physically Different" (*Sinister Wisdom* 7), as well as historical articles in *The Blatant Image* and *Frontiers: A Journal of Women Studies*. Her book, *Radical Feminists of Heterodoxy: Greenwich Village 1912–1940* (New Victoria Publishers, Lebanon, N.H., 1982; revised edition, 1986), examines the lives of nearly 125 women. Judith's research on the Heterodoxy members, many of whom were lesbians, was sparked by a club photograph album from 1920. She is a member of the Lesbian Herstory Archives collective, and a co-founder of Lesbian Heritage / DC, which is no more. She currently lives just outside of Philadelphia.

1. Margery Mann, *Women of Photography: An Historical Survey* (San Francisco: San Francisco Museum of Art, 1975), p. 4.

2. Tee Corinne, "Clementina Hawarden, Photographer," *Sinister Wisdom* 5 (Winter 1978), p. 45. Also see *Clementina, Lady Hawarden*, edited by Graham Ovenden (New York: St. Martin's Press, 1974).

3. Mann, *Women of Photography*, p. 6.

4. Toby Quitslund, "American Women Photographers," session and slide show at First National Conference, National Women's Studies Association, Lawrence, Kansas, May 31, 1979.

5. Annie Gottlieb, introduction to *Women See Woman*, edited by Cheryl Wiesenfeld et al. (New York: Thomas Crowell, 1976), p. 2.

6. Ibid., p. 3.

7. United States Census Office, *Twelfth Census, 1900. Occupations.* (Washington, DC: Government Printing Office, 1904), p. lii, quoted in Quitslund, "American Women Photographers."

8. Emma Jane Gay Papers, Jane Gay Dodge Collection, Schlesinger Library, Radcliffe Institute for Advanced Study, Harvard University.

9. "Choup-nit-ki with the Nez Percé," Emma Jane Gay Papers, Jane Gay Dodge Collection, Schlesinger Library, Radcliffe Institute for Advanced Study, Harvard University. Further research has shown that E. Jane Gay was not, as stated on page 8, the official government photographer with Fletcher in Idaho. She made photographs during her trips to Idaho, without official government status.

10. Pete Daniel and Raymond Smock, *A Talent for Detail: The Photographs of Frances Benjamin Johnston, 1889–1910* (New York: Harmony Books, 1974), pp. 13–17. Also see *The Hampton Album*, introduction by Lincoln Kirstein (New York: The Museum of Modern Art, 1966); Anne Tucker, *The Woman's Eye* (New York: Alfred A. Knopf, 1973).

11. Oliver Jensen, ed., *The Revolt of American Women* (New York: Harcourt Brace Jovanovich, 1952). Also see Anne Novotny, *Alice's World: The Life and Photography of an American Original: Alice Austen, 1866–1952* (New York: Chatham Press, 1976).

12. David Vestal, introduction to *Photographs*, by Berenice Abbott (New York: Horizon Press, 1970), pp. 13–15. Also see Berenice Abbott, *New York in the Thirties* (1939; reprinted New York: Dover Publications, 1973); Anne Tucker, *The Woman's Eye*, ibid.

13. Berenice Abbott, *Marlborough Exhibition Catalogue*, January 6–24, 1976, pp. 6–7.

14. Based on an interview with Joan E. Biren, June 7, 1979.

15. Ginny Vida, ed., *Our Right to Love: A Lesbian Resource Book*, produced in cooperation with the women of the National Gay Task Force (Englewood Cliffs, NJ: Prentice-Hall, Inc., 1978).

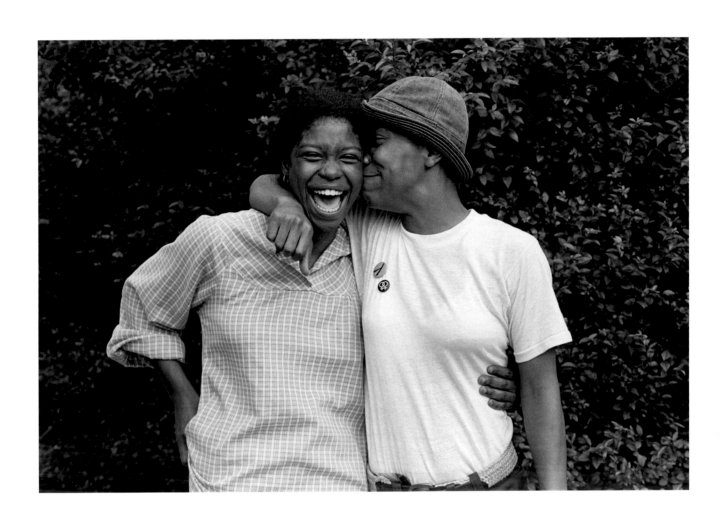

Gloria and Charmaine. Baltimore, Maryland. 1979

you are what is female
you shall be called Eve.
and what is masculine shall be called God.

And from your name Eve we shall take
the word Evil.
and from God's, the word Good.
now you understand patriarchal morality.

Judy Grahn
THE WORK OF A COMMON WOMAN

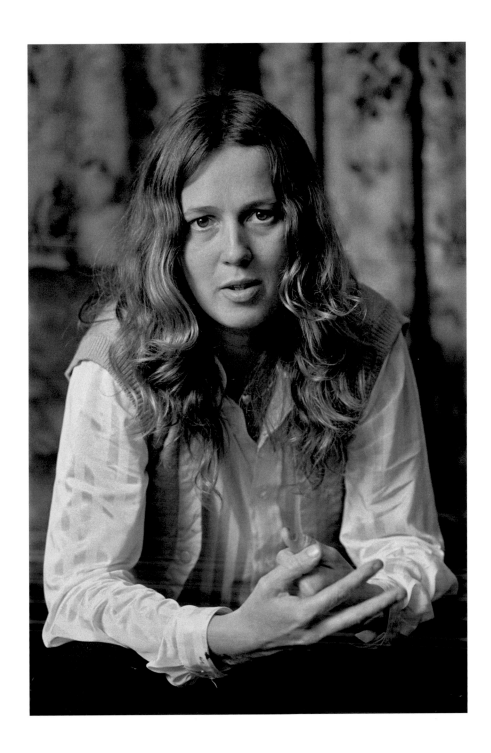

Chris. Boston, Massachusetts. 1978

We believe that we are part of a changing universal consciousness that has long been feared and prophesied by the patriarchs. The Great Goddess is bringing back her worship and the memory of her daughters—the witches and amazons. We gave birth to society long ago and we can remake tomorrow's society.

Z. Budapest
THE FEMINIST BOOK OF LIGHTS AND SHADOWS

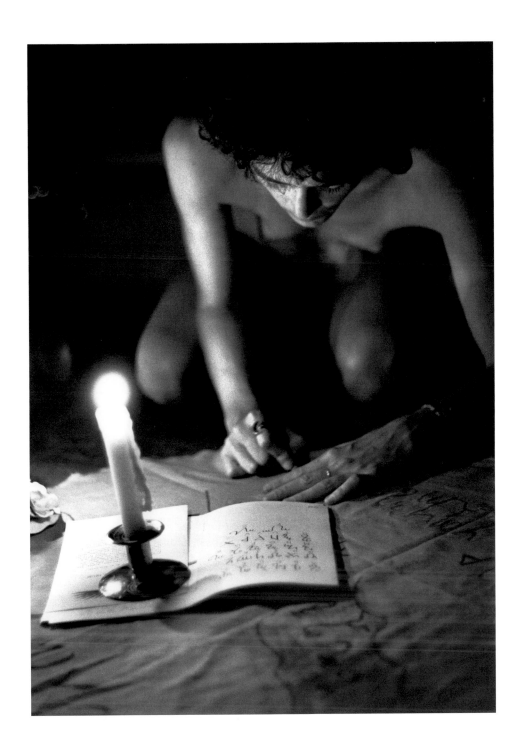

Spotts. Washington, DC. 1977

Under the domination of the egg, one usually finds a prevalence of peaceful, uterine life, satiated, comfortable, complacent, though determined in its defense against outsiders. A matriarchal realm hardly knows such a thing as a war of conquest, although the defense of the domestic egg is stalwart and brave.

Helen Diner
MOTHERS AND AMAZONS

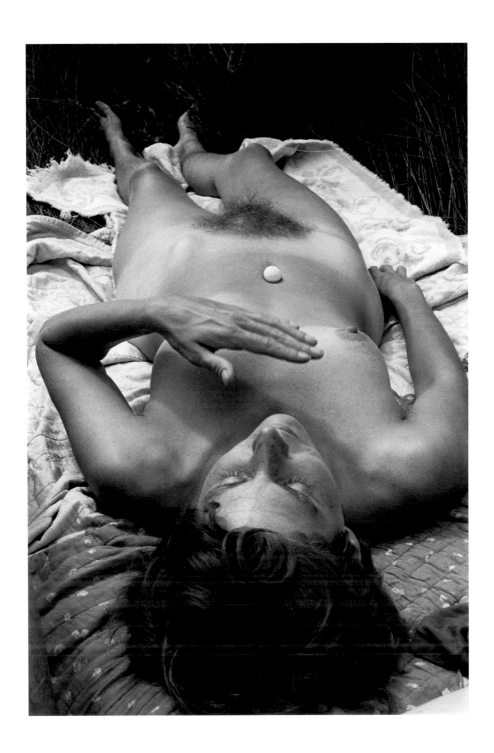

Mara. Broomes Island, Maryland. 1976

Cats protect people from diseases carried by rodents. In the 14th century the bubonic plague killed 25 million people. This plague was possible because men, associating cats with witches and the devil, killed almost the entire cat population of Europe.

Liza Cowan and Penny House
DYKE, A QUARTERLY

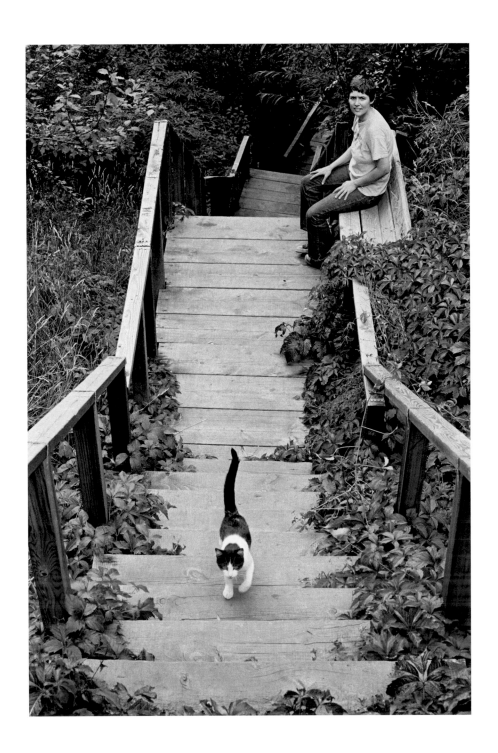

Cat and Mary. Deadwood, South Dakota. 1977

For a Lesbian in this society there is plenty to feel angry or sad about. We don't have the power. They can deny us the right to earn a living, to keep our children, to have a place to live, to be open about who we are. In order to survive you have to be aligned with men or be prepared to fight. Sometimes Lesbians forget how hard this struggle is, but it makes us strong and it makes us grow.

Lenora Trussell

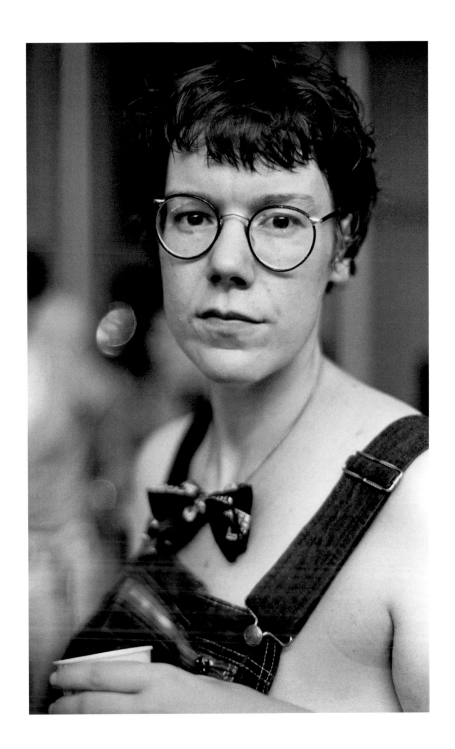

Lenora. Washington, DC. 1977

Jamey: I met Melanie at a Lesbian Mothers' Conference. There was a kids' workshop and we were there. And then we started playing together. And then she said she was hungry, so I brought her to our van. Then we got to be good friends. That's how our mothers got together. (Eight years old)

Lynne: Somehow there has to be a consciousness in the gay community—and it's growing—that children are a community's collective responsibility, because traditional mothering is much too isolated and painful. (Twenty-eight years old)

Susie: Sometimes being with womyn who don't have kids is real hard. Womyn talk about matriarchy and revolution and then ignore the kids—it's so bizarre. The kids are the revolution to me. When Melanie and Jamey grow up, they are going to be powerful womyn that we can't even imagine. (Thirty-one years old)

Melanie: My friend was teasing me when I told her who I was going to love when I grew up. My mind thought, "Does she love her mother? Yes. Well, then it's no big deal! 'Cause it's almost just like loving your mother." (Six years old)

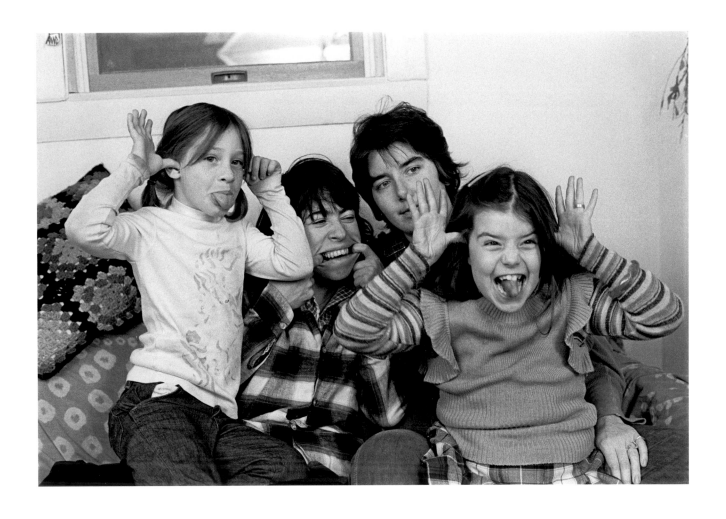

Melanie, Lynne, Susie, and Jamey. Boston, Massachusetts. 1978

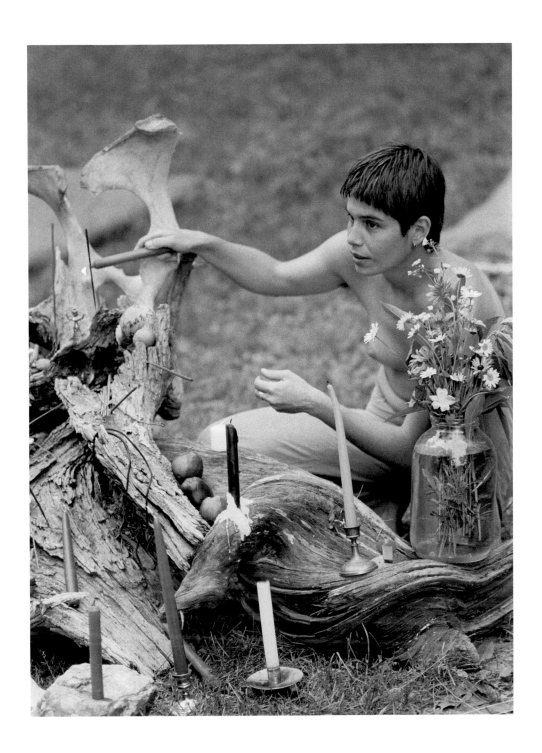

Flo. Flint Hill, Virginia. 1978

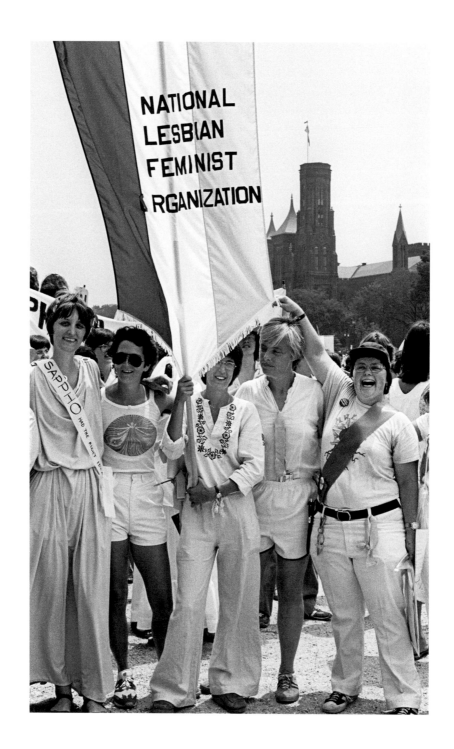

ERA March. Washington, DC. July 9, 1978

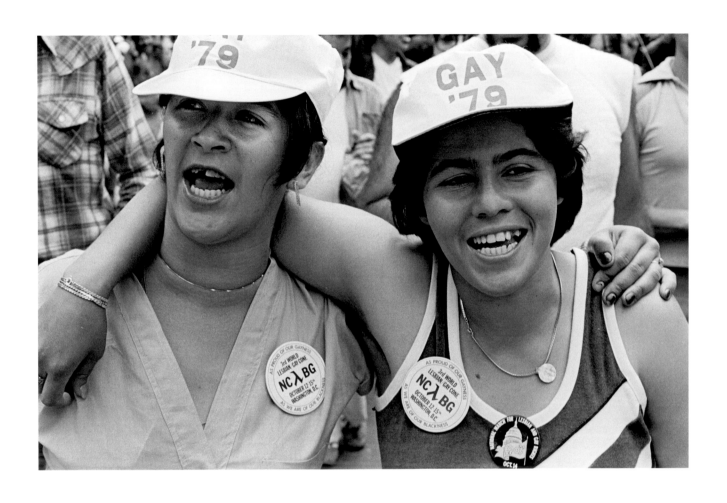

Maria and Tracy. New York Lesbian and Gay Pride March. June 24, 1979

There is a disabled closet as well as a Lesbian closet. It was an easy transition for me to come out as a Lesbian because I always had to be a really strong woman. Somehow I felt that women who know what their oppression is about would see beyond disability—that higher consciousness would carry over. Now I don't think so. People will say, "Here, let me help you." Sometimes disabled people don't need help. The major thing is not to think you know how to help someone without listening to her.

Connie Panzarino

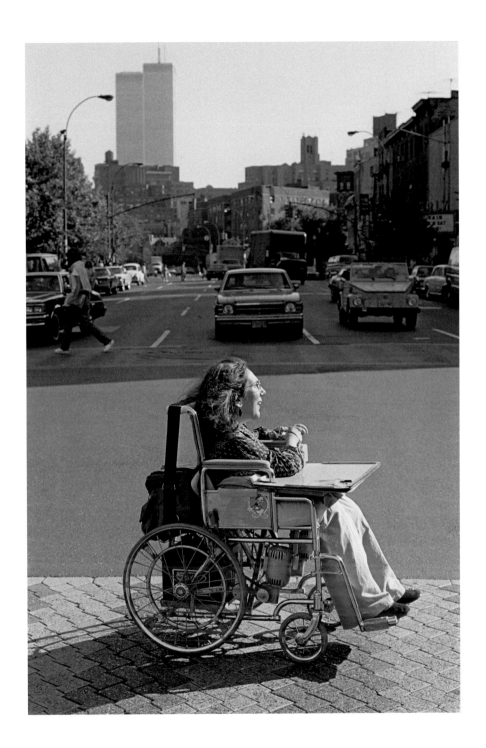

Connie. New York City. 1979

Everything revolved around getting drunk. Finally I had to say to myself, "I can't wake up another morning like this." I knew I was drinking too much. So I decided that whatever it took, no matter how hard it was, I would stop drinking. I think womyn can and should help each other to do this. Addiction has to be dealt with on a broader level in womyn's communities. We need more programs like the Women's Alcoholism Program in Cambridge and the Alcoholism Center for Women in Los Angeles.

My lesbianism has been my strength. It's the one thing I've never doubted.

Claudia McCarthy

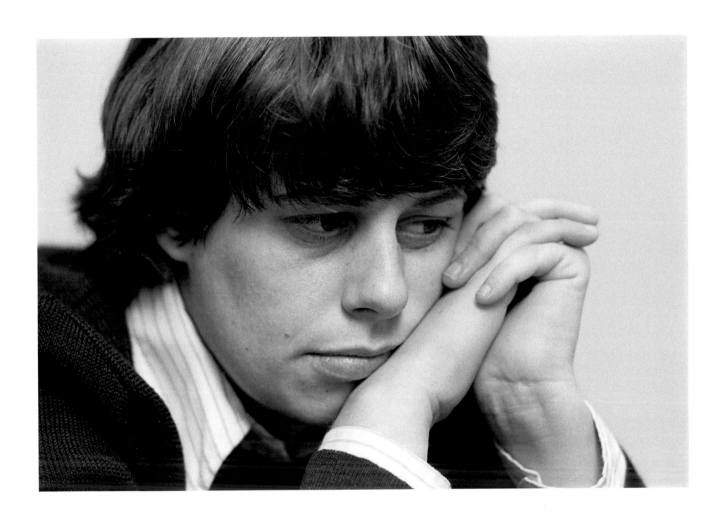

Claudia. Alcoholism Treatment Unit, Western Massachusetts Public Hospital. 1978

My theory is that women started karate. The power for karate (in all styles except for the very newest) comes from the hips, which is where women's power is centered.

One of the basic things in karate is that you can control your own energy. We've taken that further in women's karate by saying we can control our own energy and we can share energy together. We all have to be concerned about each other's strength.

Wendi Dragonfire

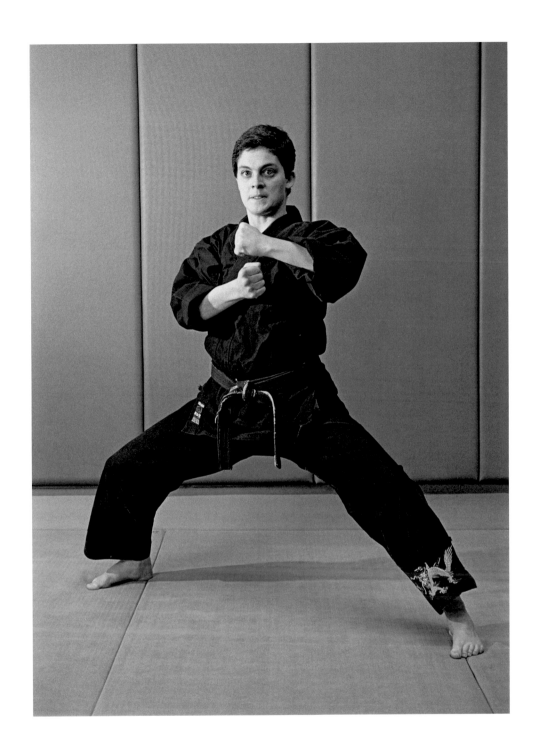

Wendi. New Haven, Connecticut. 1979

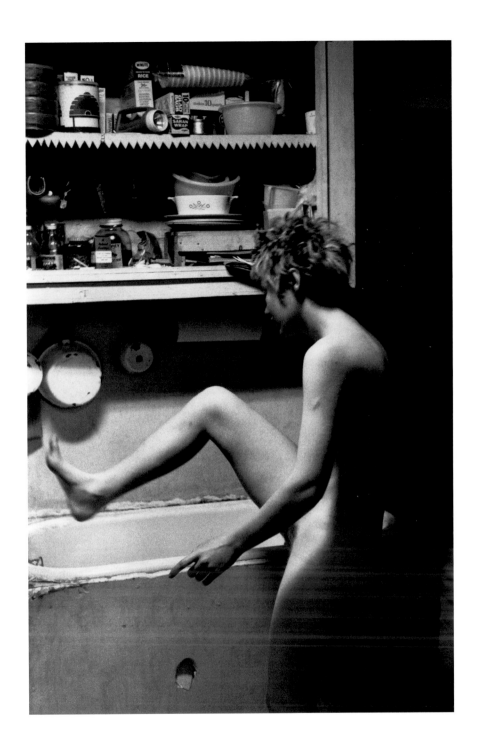

Donna. New York City. 1970

I figured out once that I'd spent over two years inside hospitals. My official diagnosis is paranoid schizophrenia. I'm into taking responsibility for my own craziness, because if you don't, then you have an absolutely wonderful excuse for being crazy the rest of your life.

My being a Lesbian—it's so very comfortable, it's who I am and that in no way can be called crazy.

Judy Castelli—artist, singer and songwriter

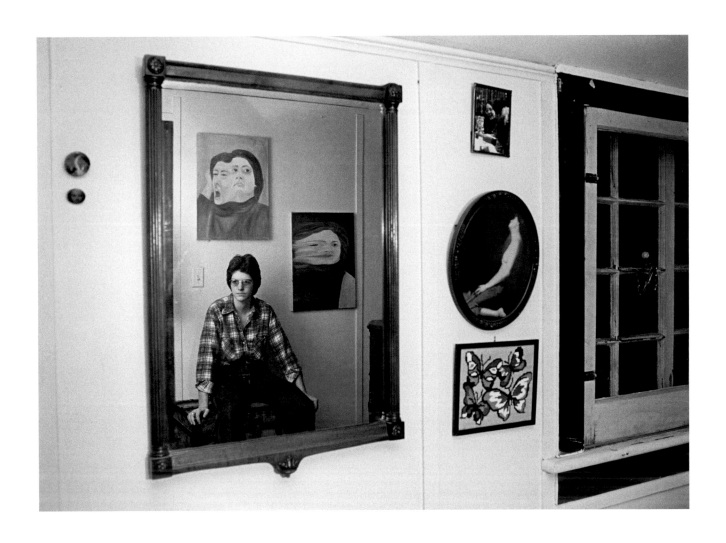

Judy. Huntington, New York. 1978

In a bar, if you're scared to meet people, all you have to do is get to the pool table. Pool is a poetic game and it's one of the few games that I play. I play chess and pool. I don't have time for games, because I have to play games all day long. I sell office supplies. And I can't be Rusty in that store, I have to be Mary Ellen. Pool is a way to relax and calm down.

Rusty Slesinger

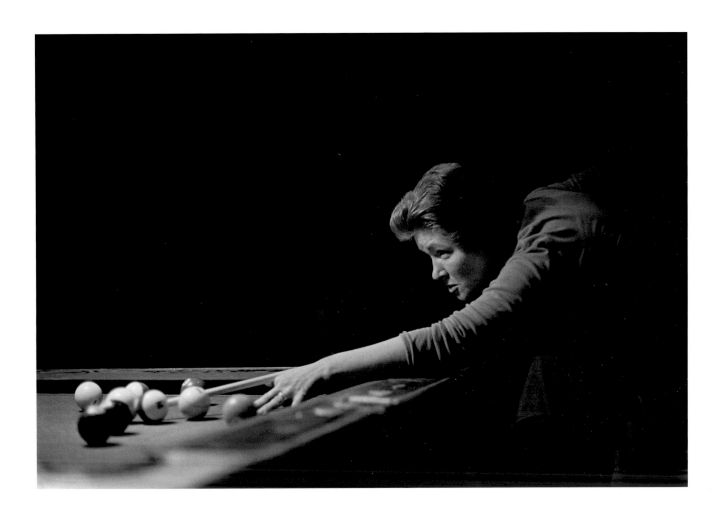

Rusty. Washington, DC. 1979

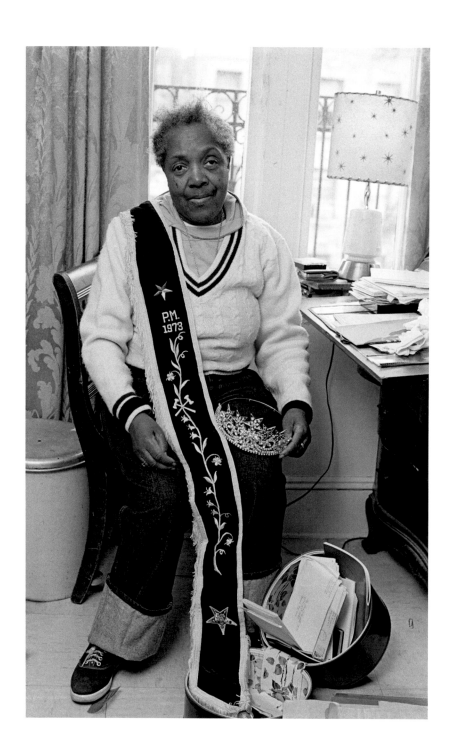

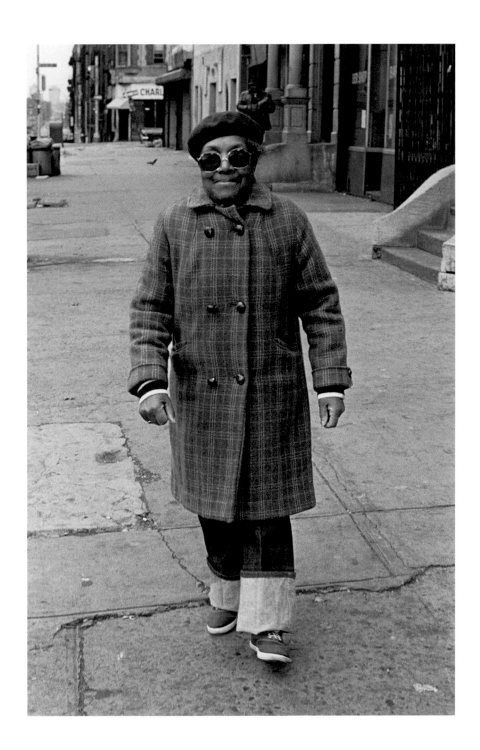

Mabel. New York City. 1978

Julie: Both Jinny and Jinx are my lovers, but they're not lovers with each other. Jinx and I had no plan to fall in love. When you have a stable relationship like the one Jinny and I had for twenty-two-and-a-half years, at age fifty—Jinny was fifty-six and Jinx was forty-nine—upsetting the whole apple cart is not the wisest thing to do.

Jinny: I was basically pretty monogamous and it upset me a lot.

Jinx: I think monogamy is a very bad trip. I think being shackled to one person always would be the most boring thing in the world.

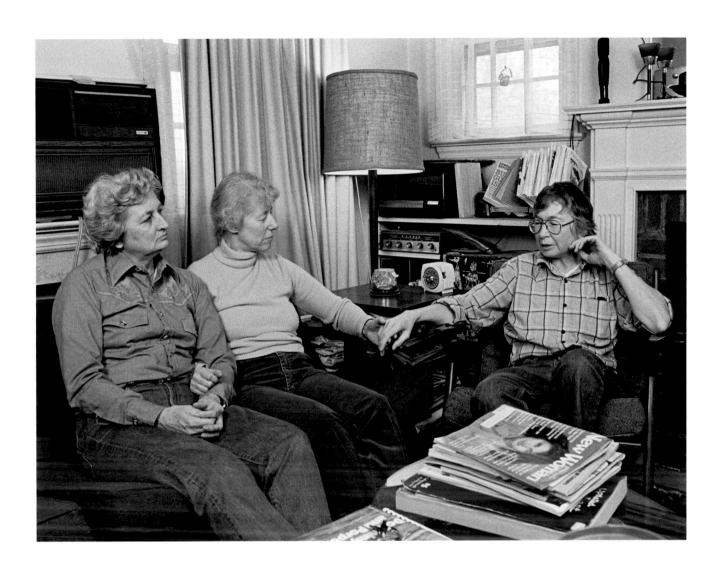

Jinx, Julie and Jinny. Scotch Plains, New Jersey. 1978

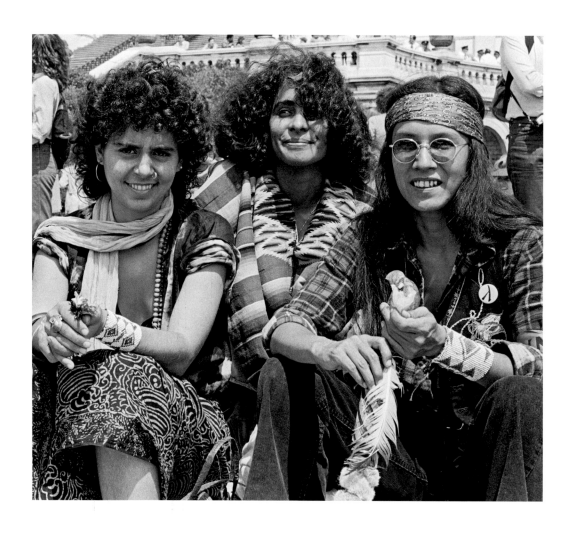

Makara, Marta and Burning Cloud. Washington, DC. 1979

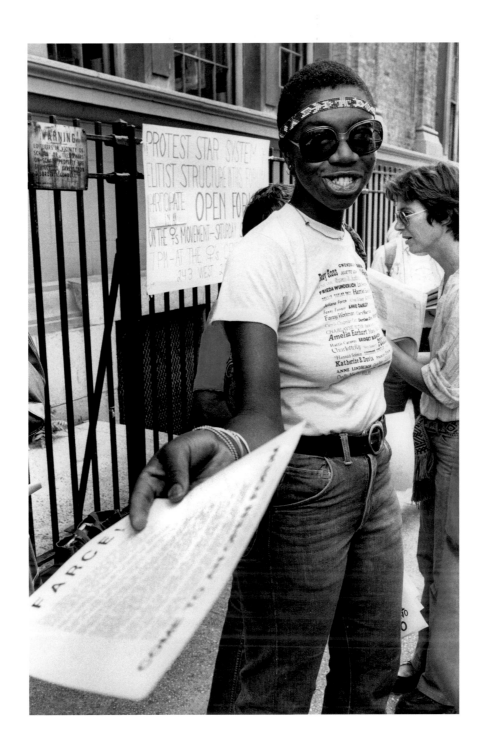

Gwendolyn. New York City. 1978

Being a Lesbian has released a lot of energy for me. The movements I'm a part of—the Black feminist movement and the women's movement—have given me a place to put that energy. The existence of the Lesbian community, a community that defies man-made boundaries, is extremely important to me. I especially cherish my unique identification with Black Lesbians both present and past, here and in all the places we find ourselves as African women.

Beverly Smith

After years of constant work, I'm feeling good that we finally have a viable Black feminist movement. We're just beginning to comprehend all the things it means to be Black and female and Lesbian in America. What bothers me most is that racism in the women's movement and homophobia in the Black community are, after white-male patriarchy, the forces most likely to choke Black feminist struggle.

Barbara Smith

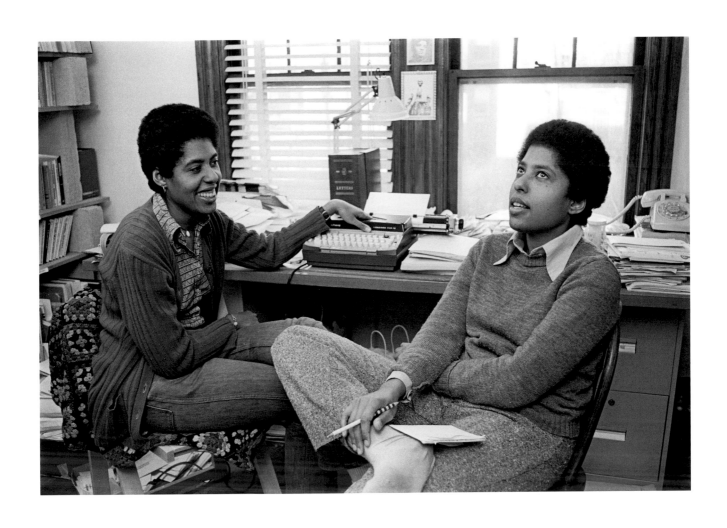

Barbara and Beverly. Roxbury, Massachusetts. 1978

Once you know that technology is just learning how to do things, you don't have to worry anymore, you have autonomy. I had a lot of fear of technology, not because of the machines, but because it meant dealing with those awful people. There is all this intimidating stuff around cars, because cars represent the power of being able to cope, to get around in the world. If you know how to do that, you begin to realize how much more you can do. You can do anything you want.

Valerie Mullin

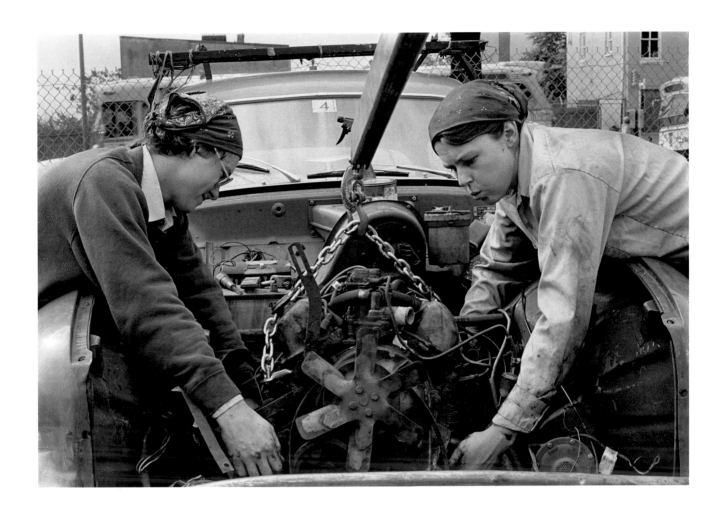

Lori and Valerie. Washington, DC. 1978

There is always that question: how to treat the land well? Shall I build like our ancestors, to last forever? Or like the First Peoples, to leave no trace? Where to get the money—and the time after working for the money and the energy to live up to my loving—to not betray this land with my carelessness or expediency?

Sherry Thomas
COUNTRY WOMEN

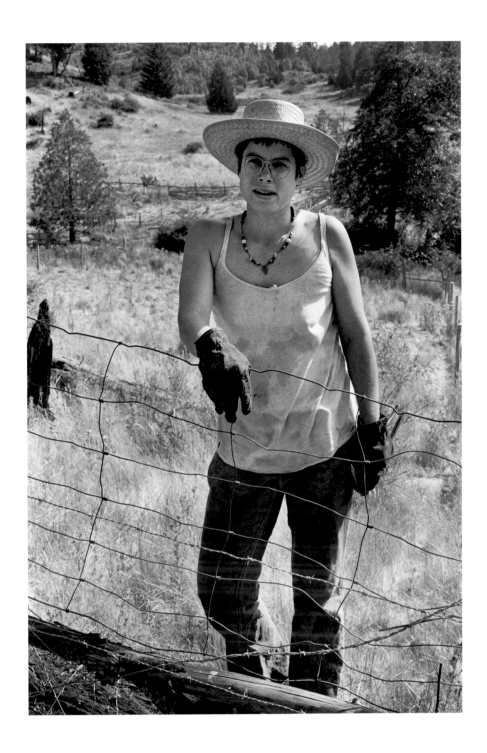

Liz. OWL Farm, Days Creek, Oregon. 1977

In the morning she makes a muscle with her right arm, in the bicep. It doesn't count what it looks like, you have to try to push it down. I try, but it is very hard. She is pleased then, and squinches her eyes in delight, because she is a strong woman and has hard muscles.

Elana Dykewomon
THEY WILL KNOW ME BY MY TEETH

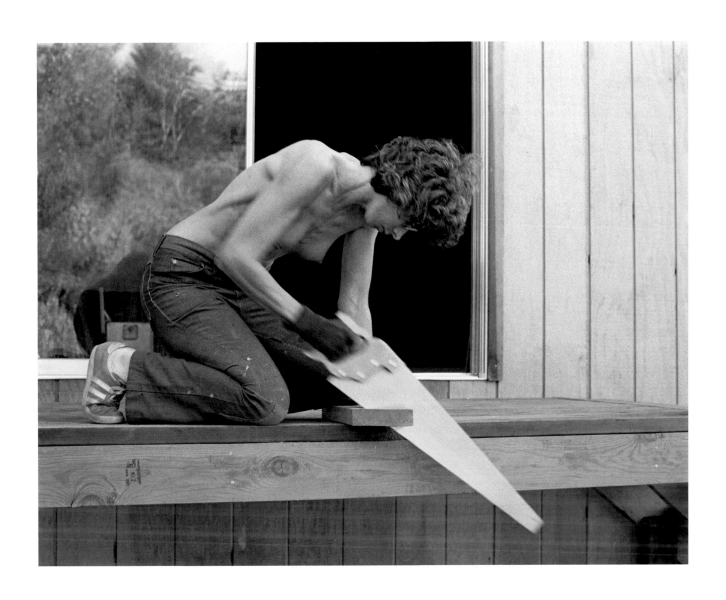

Jane. Willits, California. 1977

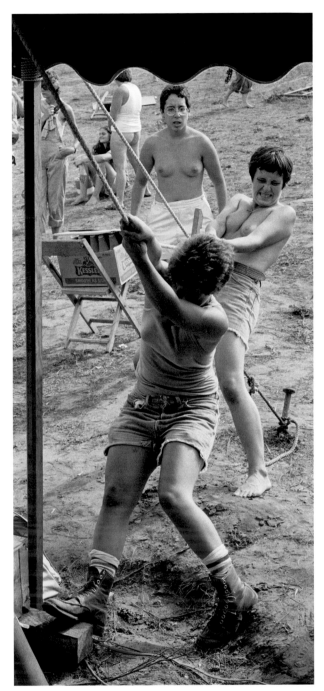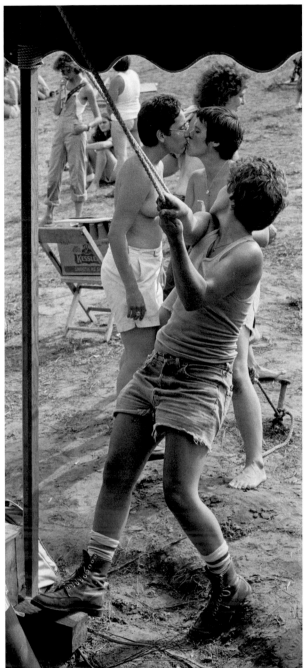

Pat, Lisa and Moka (rear). *Michigan Womyn's Music Festival. 1977*

I'm fifty-seven and I came out when I was five. I've never had any regrets about being gay and I've never hidden it. I've got an attitude where if somebody doesn't want my talent, they can go to hell. I'm a good cook. I want to open a gay restaurant of my own with all gay people working there. Why should somebody spend gay money and give it to straight people?

Dot Palmerton

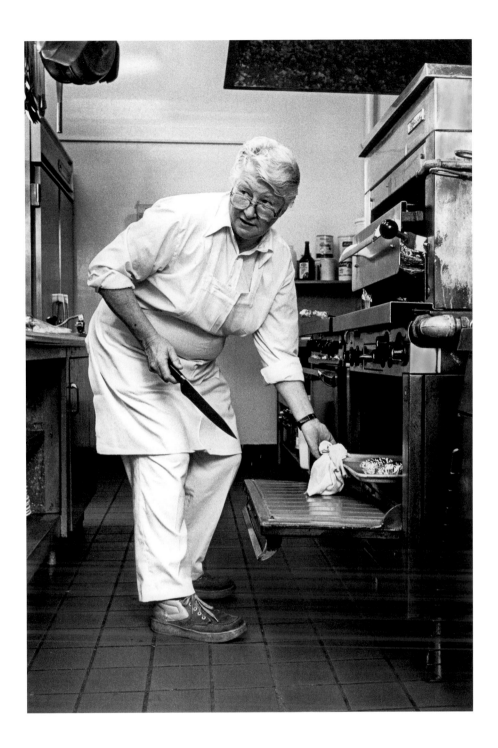

Dot. Washington, DC. 1979

Some days things go so badly, you feel like you're going to cry. The other days, it's a great feeling, being different. It might not take being a Lesbian, but it certainly takes being independent and assertive to do this kind of work. Otherwise you won't last through the comments, the snide remarks and the crude jokes. For me, it almost becomes revenge; I'll never quit.

Joan Fortney

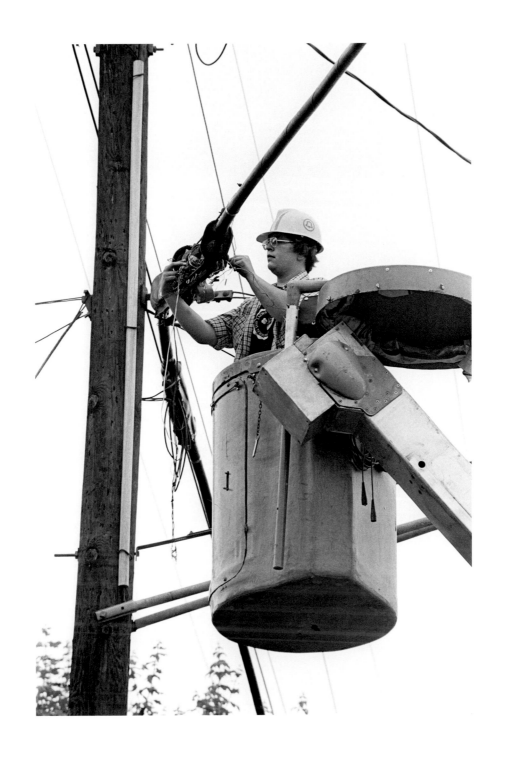

Joan. Mt. Rainier, Maryland. 1979

I've always been a lesbian. Early in my life, I had a conscious awareness that I'd better know everything there is to know about surviving, because I was going to be responsible for myself. My strength developed through day-to-day kinds of labor like moving furniture, shoveling snow and pushing my car.

Powerlifting—using weights—directly confronts the belief that women are weak. We all have muscles and we can all make them stronger. It gives you a lot of power dealing with men. When you know your body is just as good as his, you can't be physically intimidated.

Susan Smith

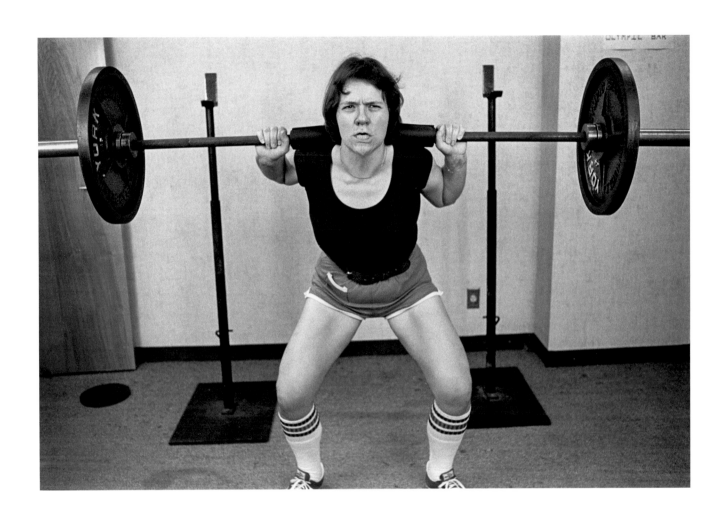

Susan. Washington, DC. 1979

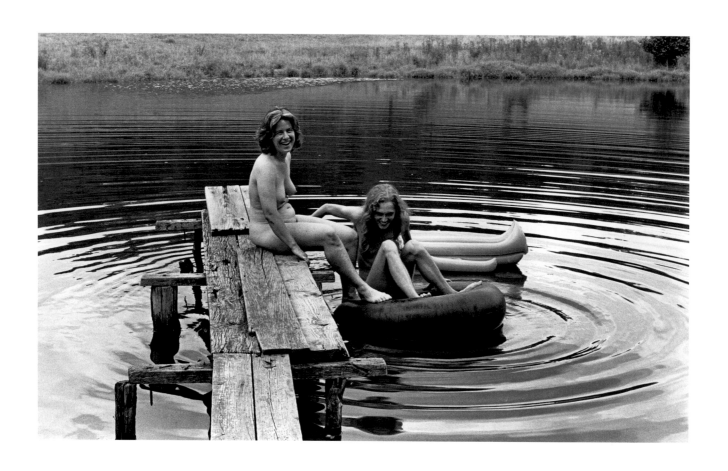

Betsy and Pam. Flint Hill, Virginia. 1978

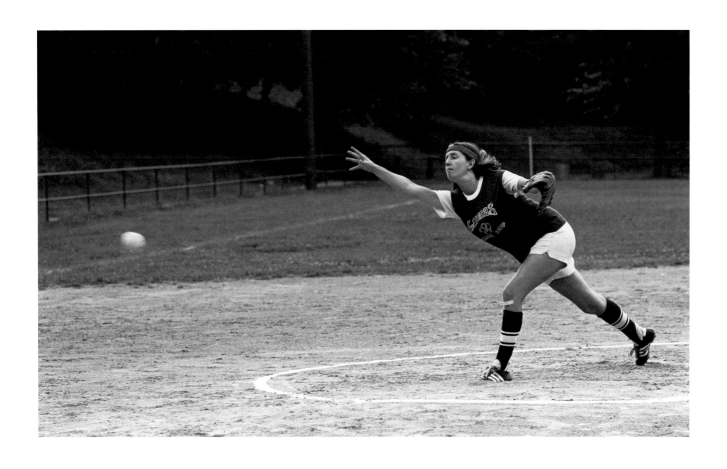

Markie. Washington, DC. 1976

Pagan: I had the dream American home in the suburbs with the cars and the garden and three children. I thought I was doing what I was supposed to be doing, but I felt like a miserable failure anyway. And then I started reading all that feminist literature.

Kady: When we moved into this house together, Pagan had been cooking for her family for twenty-five years and so she wouldn't cook at all. I cooked the first dinner and the frozen vegetables were still icy when we bit into them. "Tastes fine to me," she said.

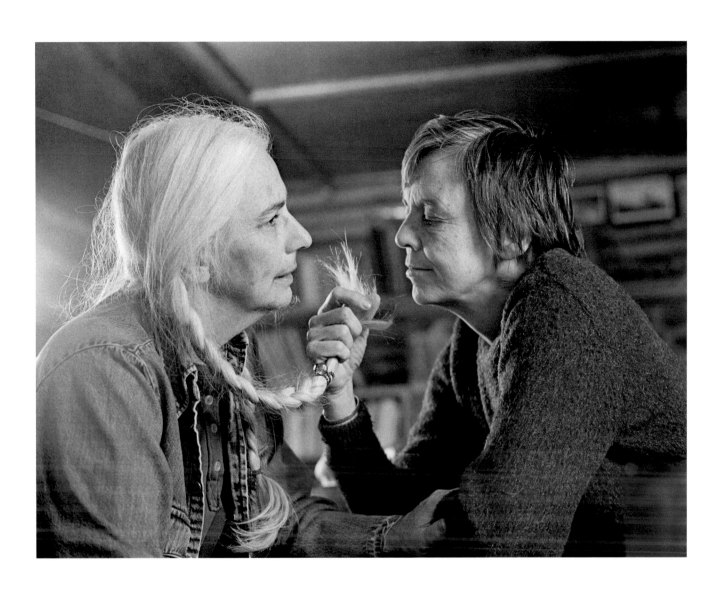

Pagan and Kady. Monticello, New York. 1978

WOMAN

I dream of a place between your breasts
to build my house like a haven
where I plant crops
in your body
an endless harvest
where the commonest rock
is moonstone and ebony opal
giving milk to all of my hungers
and your night comes down upon me
like a nurturing rain.

Audre Lorde
THE BLACK UNICORN

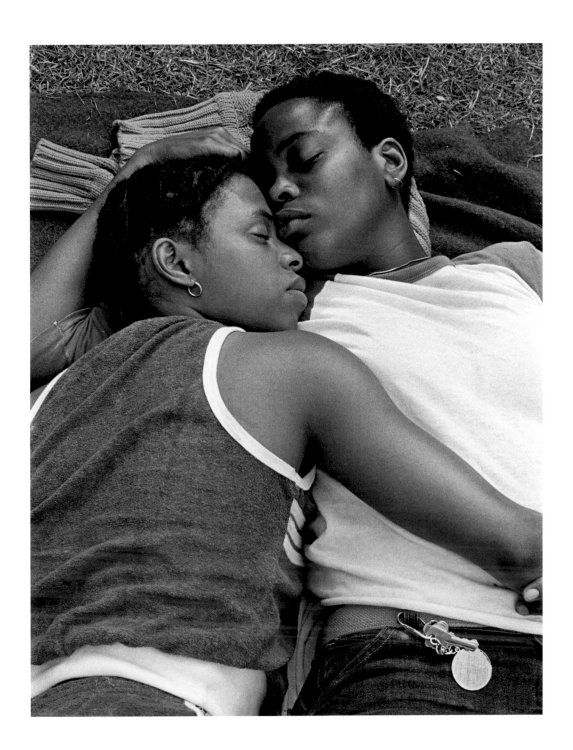

Priscilla and Regina. Brooklyn, New York. 1979

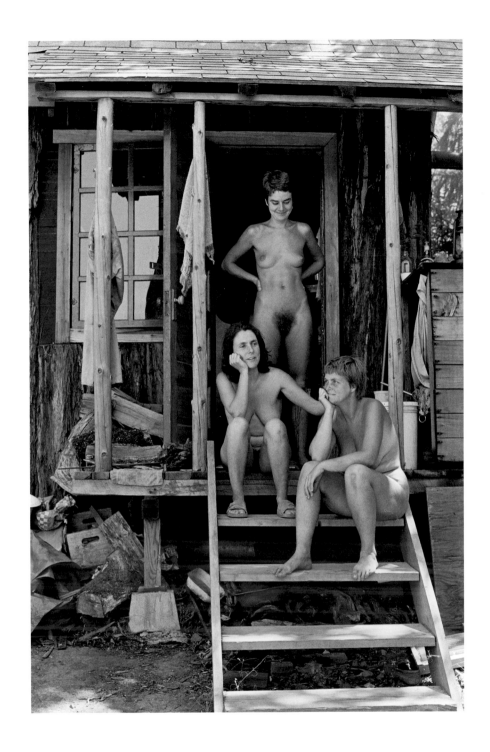

Summer (rear), *Morning and Meadow. Willits, California. 1977*

I thank the kind spirits and Goddesses for a beautiful daughter, womyn-child. Darquita Sharleen has always been a very happy child, especially when she awakens in the morning, always with a smile. It's like having the sun shine on me every morning. She is a child of the world. I want her to listen, learn and experience from her womyn-folks because they have stories to share with her.

Denyeta

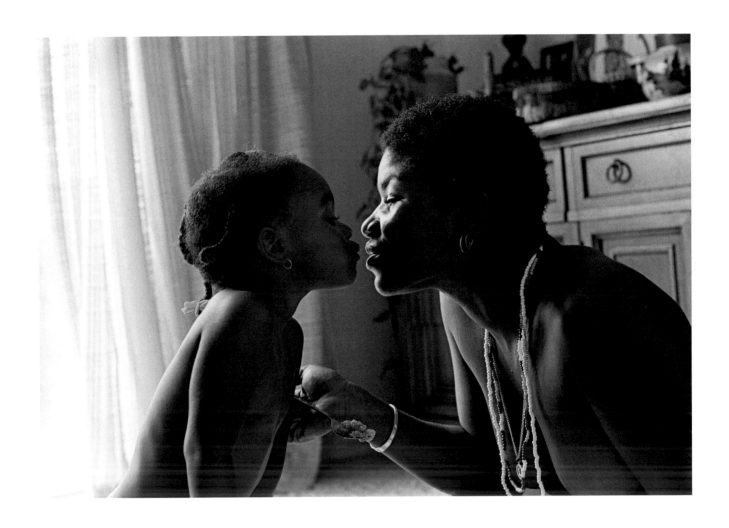

Darquita and Denyeta. Alexandria, Virginia. 1979

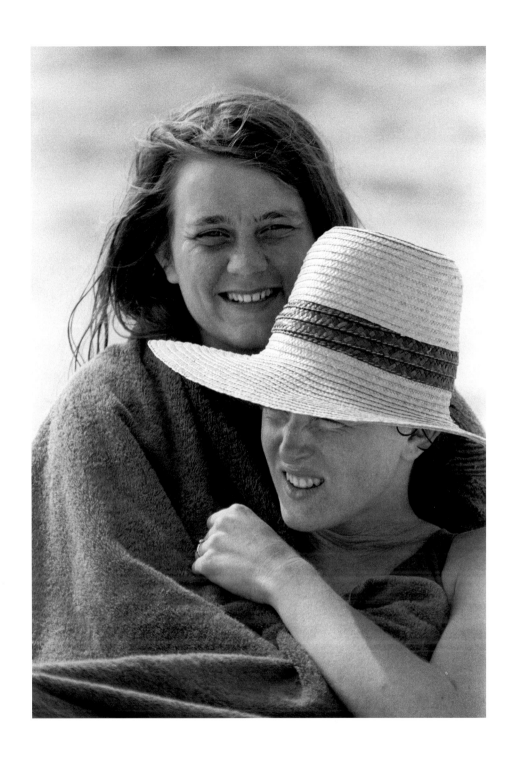

Lois and Julie. Outer Banks, North Carolina. 1978

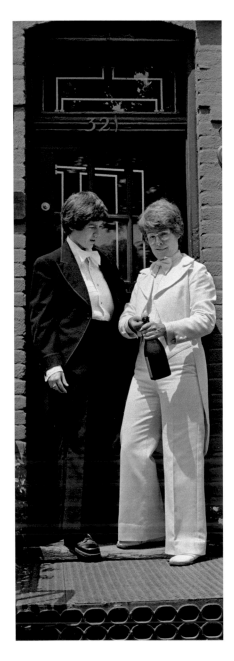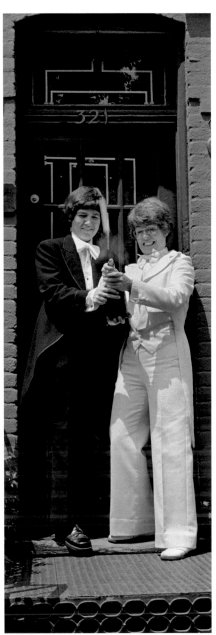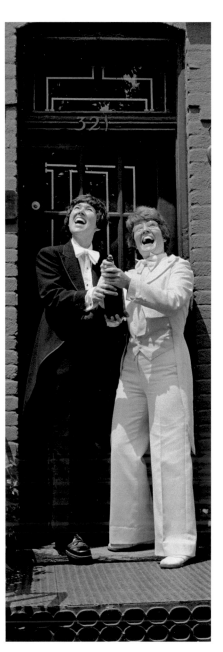

Mary and Tina. Fourth Anniversary of Lammas Women's Shop, Washington, DC. 1977

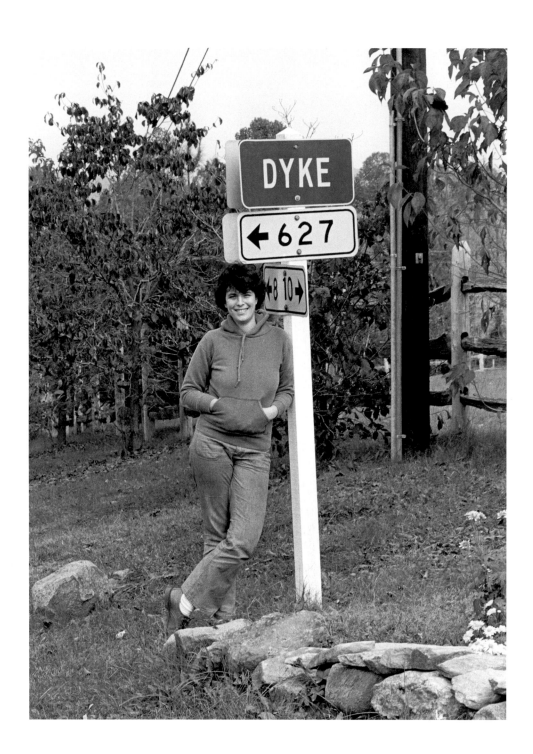

JEB. Dyke, Virginia. 1975

Afterword

Growing up, I was a unique little girl, a major tomboy whose clothes never matched. All I ever wanted to do was splash on my brother's Brut cologne, slick back my mullet, and ride my skateboard around the neighborhood while blasting Cyndi Lauper on my boombox. I thought I was pretty cool, but the best part was that my mom encouraged it. In fact, I think she thought I was just as cool as I did.

My mom came out as a lesbian in 1982 in a place—Indiana—that was not supportive of the LGBTQ+ community, and although it wasn't easy, she had the courage to live her truth. She fostered this same fortitude in me and my brother. I'm extremely grateful for my childhood and the freedom it afforded me to express who I was.

As early as I can remember, we were immersed in queer culture. We attended music festivals, which provided my first exposure to a diverse queer community that included Black women, femmes, and butch women. It was the first time I saw a woman topless. *Whoa!*

We attended numerous pride parades and festivals, and participated in annual Memorial Day weekend camping trips with my mom's friends. Growing up with these individuals and seeing how vibrantly they lived their lives was pivotal in formulating my worldview. It's not lost on me how impactful my childhood was on my own process of coming out and understanding my sexuality.

When I see JEB's photographs, they remind me of that childhood. They give me a glimpse into my past. I'm reminded of the queer love and joy I witnessed on a regular basis.

As JEB has stated, "I couldn't picture being a lesbian, life as a lesbian, because there were no lesbians living out lives to see." She has given us, the queer community, those missing pictures through her art.

This is why JEB's work is so important. Her photographs in *Eye to Eye: Portraits of Lesbians* and her broader work give us a proof of context: a lens into other people's lives that helps us make sense of who we are, how we're feeling, and what we're fighting for.

With social media, it is much easier to see images of LGBTQ+ people today, but it's JEB's pictures that helped pave the way for my generation. What a wonderful gift from JEB, for her to have had the foresight to document what was happening during her time and what the people surrounding her were feeling.

There is no doubt we have a long fight ahead of us when it comes to the liberation of *all* people. We will continue to look to JEB's work not only as inspiration for all of us to live as our true selves, without apology, but also as a historical touchstone for future generations of queer people going forward.

Lori Lindsey

UPDATED NOTES AND RESOURCES

PAGE

1. The lines from "Transcendental Etude". Copyright © 2016 by the Adrienne Rich Literary Trust. Copyright (c) 1978 by W. W. Norton & Company, Inc. from *Collected Poems: 1950–2012* by Adrienne Rich. Used by permission of W. W. Norton & Company, Inc. I would like to thank Beth Hodges for suggesting the title of my book, *Eye to Eye*, and for pointing out these lines to me.

2. My publishing name, Glad Hag Books, was inspired in part by reading *Gyn/Ecology: The Metaethics of Radical Feminism* by Mary Daly (Beacon Press, 1978; revised edition 1990).

 The Joan E. Biren Papers (composed of JEB's professional work and personal papers) are archived in the Sophia Smith Collection of Women's History at Smith College in Northampton, MA. The complete finding aid is available at findingaids.smith.edu/repositories/2/resources/915.

5. Toni White is now known as Maya White Sparks.

7. Joan Nestle is one of the founders of the Lesbian Herstory Archives, which gathers and preserves material by and about Lesbians. Now located in Brooklyn, NY, the LHA welcomes all to visit, explore the collection, and do research at lesbianherstoryarchives.org.

11. Tee Corinne's essay originally appeared in the catalog for *Queerly Visible: The Work of JEB (Joan E. Biren) 1971–1991*, an exhibition presented by the Special Collections Department of the Gelman Library at the George Washington University in 1997. The complete catalog is available to download at scholarspace.library.gwu.edu /concern/gw_works/qn59q467m.

13. Judith Schwarz has an article on researching Lesbian history in *Sinister Wisdom* 5. *Sinister Wisdom* is a quarterly journal of words and pictures for the Lesbian imagination in all women. This issue also has Tee Corinne's article on Clementina Hawarden. Subscriptions and back issues, including no. 5, are available at sinisterwisdom.org.

20. This poem is from Judy Grahn © *The Work of a Common Woman: Collected Poetry (1964–1977)*, originally published in 1978 by Diana Press and republished by Crossing Press and St. Martin's Press.

22. These lines are from the manifesto of the Susan B. Anthony Coven #1, which is printed in *The Feminist Book of Lights and Shadows*, copyright © 1975 by Z. Budapest and The Feminist Book of Lights and Shadows Collective. Used by permission. *The Holy Book of Women's Mysteries: Part One* now incorporates all this material and more, and is currently in the process of being re-released. For more information, visit zbudapest.com.

24. Excerpt from *Mothers and Amazons* by Helen Diner © 1965 by The Julian Press, Inc. Used by permission of The Julian Press, imprint of Penguin Random House, LLC. All rights reserved. I don't know if Helen Diner (who also wrote under the name of Sir Galahad) was a Lesbian. I do know that in Germany in the 1930s, she explored "matriarchy, gynocracy, and other forms of female predominance." Two other a-mazing books I would like to mention are *When God Was a Woman* by Merlin Stone (Harvest/Harcourt, Brace, 1978) and *Woman and Nature: The Roaring Inside Her* by Susan Griffin, first published in 1978, reissued by Counterpoint in 2016.

26. Liza Cowan and Penny House edited *DYKE, A Quarterly*, which is no longer published. This quote, used by permission, is from the final issue: no. 6, summer 1978. An online annotated archive can be found at dykeaquarterly.com.

28. The National Center for Lesbian Rights fights for the rights of the LGBTQ+ community and our families through precedent-setting litigation, legislation, policy, and public education; see nclrights.org. The National LGBTQ Task Force works to advance full freedom, justice, and equality for LGBTQ+ people; see thetaskforce.org.

30. Children of Lesbians and Gays Everywhere (COLAGE) is a national organization operated by and supporting children of LGBTQ+ parents; see www.colage.org. Family Equality envisions a future free of discrimination and maximizes opportunities for LGBTQ+ youth in need of permanency and LGBTQ+ adults seeking family formation through adoption, foster care, assisted reproductive technology, or other means; see familyequality.org. GLSEN works to create safe schools free from bullying and harassment; see glsen.org.

32. There is no quote here, but that won't stop me from recommending a valuable and sexy book for self-healing: *Pleasure Activism: The Politics of Feeling Good* by adrienne maree brown asks: "How can we awaken within ourselves desires that make it impossible to settle for anything less than a fulfilling life?"

36. *The Me in the Mirror* (Seal Press 1994), is Connie's spirited and passionate memoir of her life and years of pioneering work in the disability rights movement. Leah Lakshmi Piepzna-Samarasinha explores the work that sick and disabled queer and people of color are doing to find one another and to build power and community in *Care Work: Dreaming Disability Justice* (Arsenal Pulp Press 2018).

38. NALGAP, The Association of Lesbian, Gay, Bisexual, Transgender Addiction Professionals and Their Allies, provides information, training, networking, and support to addiction professionals; see nalgap.org.

40. Empowerment self-defense (ESD) teaches practical skills to those targeted for gender-based violence—primarily women and LGBTQ+ people. The ESD Alliance offers an international directory of instructors and a list of online workshops at empowermentsd.org. The National Coalition of Anti-Violence Programs works to prevent, respond to, and end all forms of violence against and within LGBTQ+ communities. Member programs and affiliates nationwide are available at avp.org/ncavp-members. Their twenty-four-hour English/Spanish hotline is (212) 714-1141.

44. The LGBT National Help Center provides hotlines and instant messaging with peer support services for youth, elders, and people of all ages. They also have a huge database of LGBTQ+ resources across the United States. Hotline phone numbers and more information are available at glbtnationalhelpcenter.org. The National Queer and Trans Therapists of Color Network is dedicated to increasing access to healing justice resources for queer and trans people of color (QTPoC.) They provide financial assistance to QTPoC through their Mental Health Fund and offer a directory of practitioners organized by region at nqttcn.com. The Trevor Project is the leading national organization providing crisis intervention and suicide prevention services to LGBTQ+ youth. Their 24-7 lifeline can be reached at (866) 488-7386. Many other resources for LGBTQ+ youth and the adults who work with them are available at thetrevorproject.org.

48. With national and local affiliates, SAGE advocates with and on behalf of LGBTQ+ elders, with a special focus on housing. SAGE provides training in cultural competency to those who provide services to older adults. The SAGE LGBT Elder Hotline is available 24-7 in English and Spanish at (877) 360-LGBT (5428). More information available at sageusa.org. The National Resource Center on LGBT Aging is a technical assistance resource center aimed at improving the quality of services and support offered to older LGBTQ+ adults available at lgbtagingcenter.org.

49. The Lesbian Herstory Archives has more biographical information about Mabel Hampton and excerpts from her oral history tapes at herstories.prattinfoschool.nyc/omeka/collections/show/29.

50. This triad lasted for five and a half years. *More Than Two: A Practical Guide to Ethical Polyamory* by Franklin Veaux and Eve Rickert was independently published in 2014. More resources can be found at morethantwo.com. There are many articles about polyamory from an LGBTQ+ perspective at autostraddle.com/tag/poly-pocket.

54. Barbara Smith is known as the mother of Black feminism. She and her sister Beverly were co-founders of the Combahee River Collective, a radical and intersectional activist group. Barbara also co-founded Kitchen Table: Women of Color Press, which published *Home Girls: A Black Feminist Anthology* in 1983. This book, edited by Barbara and reissued by Rutgers University Press in 2000, has contributions from both Barbara and Beverly. *Ain't Gonna Let Nobody Turn Me Around: Forty Years of Movement Building with Barbara Smith*, edited by Alethia Jones and Virginia Eubanks (SUNY Press, 2014) is a primer for practicing solidarity and resistance. You can join the Donor Caring Circle to help Barbara live safely in retirement at fundly.com/barbara-2.

56. Lesbians Who Tech & Allies is a global community of LGBTQ+ women, nonbinary folks, queer women of color, and allies in tech; see lesbianswhotech.org. They strive to promote the visibility and inclusion of underrepresented people in technology and award scholarships for training in coding to queer women and nonbinary techies.

58. Excerpt from *Country Women: A Handbook for the New Farmer* by Sherilyn Thomas and Jeanne Tetrault, © 1976 by Sherilyn Thomas and Jeanne Tetrault. Used by permission of Anchor Books, an imprint of the Knopf Doubleday Publishing Group, a division of Penguin Random House LLC. All rights reserved. The book *Country Women* is a comprehensive, practical, and moving handbook for the new farmer, and will be reissued in 2021.

60. *What Can I Ask: New and Selected Poems 1975–2015* assembles poems from Elana Dykewomon's three published collections including *They Will Know Me by My Teeth* (Megaera Press, 1976). The new book was published as issue no. 96 of *Sinister Wisdom* and can be ordered at sinisterwisdom.org/whatcaniask.

63. Throughout its forty-year history (1976–2015), the Michigan Womyn's Music Festival was completely built, staffed, and run by women. The festival papers are archived at Michigan State University. The We Want the Land Coalition (WWTLC) was created to save the land that was home to the festival and to allow smaller community-generated-and-organized programs to hold events there; see wwtlc.org.

64. Lambda Legal uses litigation, advocacy, and education to combat discrimination against LGBTQ+ people; see lambdalegal.org. Their Help Desk provides information and resources relating to discrimination, with an emphasis on employment discrimination, by phone and online in English and Spanish.

66. Pride at Work is a nonprofit organization that represents LGBTQ+ union members and their allies, at prideatwork .org. It is an officially recognized constituency group of the AFL-CIO that focuses on workplace discrimination, collective bargaining rights, and religious exemptions.

72. Kady Van Deurs wrote two books that are out of print, *The Notebooks That Emma Gave Me: The Autobiography of a Lesbian*, self-published in 1978, and *Panhandling Papers: Finishing the Walk: The Women's Peace Camp at Seneca, New York* (Inland Book Co., 1990). Used copies can sometimes be found on sites like BookFinder.com.

74. "Woman", from *The Black Unicorn* by Audre Lorde. Copyright © 1978 by Audre Lorde. Used by permission of W. W. Norton & Company, Inc.

77. Most of the women in this book are thin, and now (several years after publication) I wish I had included images of fat women. *Hunger: A Memoir of (My) Body* by Roxane Gay (HarperCollins, 2017) is about food, weight, self-image, and learning to feed your hunger while taking care of yourself. *The (Other) F Word: A Celebration of the Fat and Fierce*, edited by Angie Manfredi (Amulet Books, 2019), is an anthology that was put together for young adults but speaks to everyone. It celebrates all bodies, affirming fat acceptance and self-love.

78. *Revolutionary Mothering: Love on the Front Lines*, edited by Alexis Pauline Gumbs, China Marten, and Mai'a Williams (PM Press, 2016), is an anthology that centers mothers of color and marginalized mothers' voices.

83. Kristen Hogan's book *The Feminist Bookstore Movement: Lesbian Antiracism and Feminist Accountability* (Duke University Press, 2016), explores the bookstores that were often the heart of women's communities from the 1970s through the 1990s. While most of the bookstores are gone, there are many community centers all over the country. To find one near you, visit lgbtcenters.org/LGBTCenters. More information about Mary Farmer and Lammas Books is available at archives.rainbowhistory.org/exhibits/show/pioneers/2007awardees/farmer.

84. You can follow JEB on Instagram @jebmedia. JEB would like to know what you thought of this book. She can be reached at jebmedia@hotmail.com.